VERTICAL WORLDS COLORING BOOK

by ABI DAKER

ABRAMS, NEW YORK

INTRODUCTION

As a child I used to love the drawings of the English illustrator William Heath Robinson. Every image was crammed with astounding detail: crazy machines, pulleys and levers, ropes, cogs, propellers, and wheels for every kind of contraption you could imagine. There was always something going on in every inch of the page. I remember I would stare at them for hours, completely engrossed. It was almost like entering a magical world where anything could happen.

And then, when I was older, I discovered the joys of exploring a brand new city or visiting somewhere I had never been before. I remember my first visit to London and being overwhelmed by the color, the lights, and the noise. All the hustle and bustle, the coming and going, the chatter of people and the sound of the traffic filled my head and I just couldn't wait to see more. I delighted in not knowing what was around each corner and discovering a fantastic café or tucked-away boutique—it felt as if I was making it my city. And later still, when I had a child of my own, I discovered how much fun there was to be had in a zoo or on a farm, and the feeling of adventure as we followed a winding path that led us to beautiful and amazing creatures.

When I came to create these "vertical worlds" I wanted to make drawings that would fascinate people in the same way. I wanted to transfer all the detail of a place onto the page so that you could dive into them, imagining the sounds and smells, and really feel as if you were exploring somewhere new.

In our busy lives we all deserve a little time out—a little break away from the everyday. So wherever you are, pick up your pencils and pens and get ready to set out on your own adventure in my vertical worlds.

Abi Daker

VERTICAL CITY

Take a trip through this vertical metropolis for a perfect day out in the city. Grab a coffee to go at the café and then take a stroll through the scents of the flower market. Stop by city hall to admire the architecture and then dip into the antiques store and snap up a bargain. Pop into the gallery and admire some art. Then settle down for a classic pastrami on rye for lunch at the deli. Have a little rest at the city library and read up on the classics. Then round off your day catching the latest blockbuster at the movie theater.

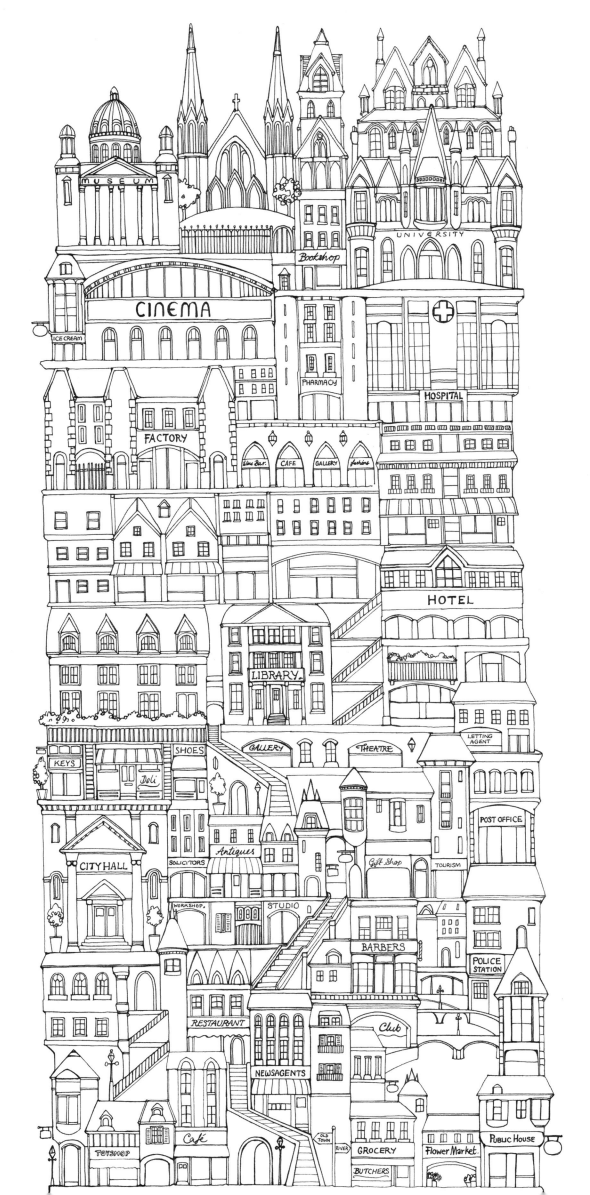

VERTICAL GREENHOUSE

A paradise of greenery awaits you under these towering crystal domes.
Unusual plants from exotic corners of the world reach all the way up to
the roof, while vines wind their way around supporting columns, echoing
the twists of the spiral staircase. The vivid butterflies darting from level to
level make the greenhouse come alive with color, as they show the way
to the tiny bridge and the gently trickling waterfall. Here you can take
a moment to reflect on the luscious foliage that surrounds you.

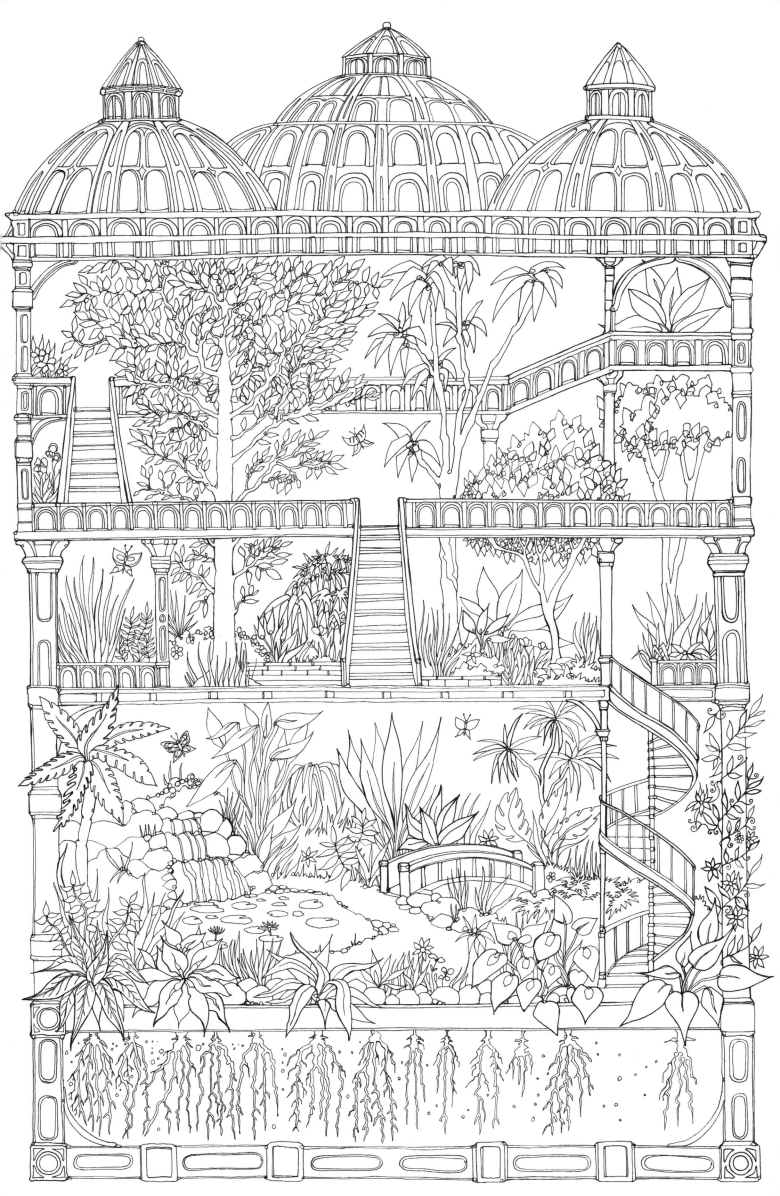

VERTICAL ZOO

We're all going to the zoo, and you can come too! Wave hello to the tall giraffes
at the gate, then head on over to the elephant enclosure and see the young calf.
Bounce past the kangaroos and see if you can spot the zebra in his stripes.
Hop on by the flamingos and take a rest by the giant tortoise. Grab yourself
an ice cream, but be sure to finish before entering the petting zoo, or you'll find
yourself sharing it! Don't forget to visit the big cats and hear the lions roar
before you leave.

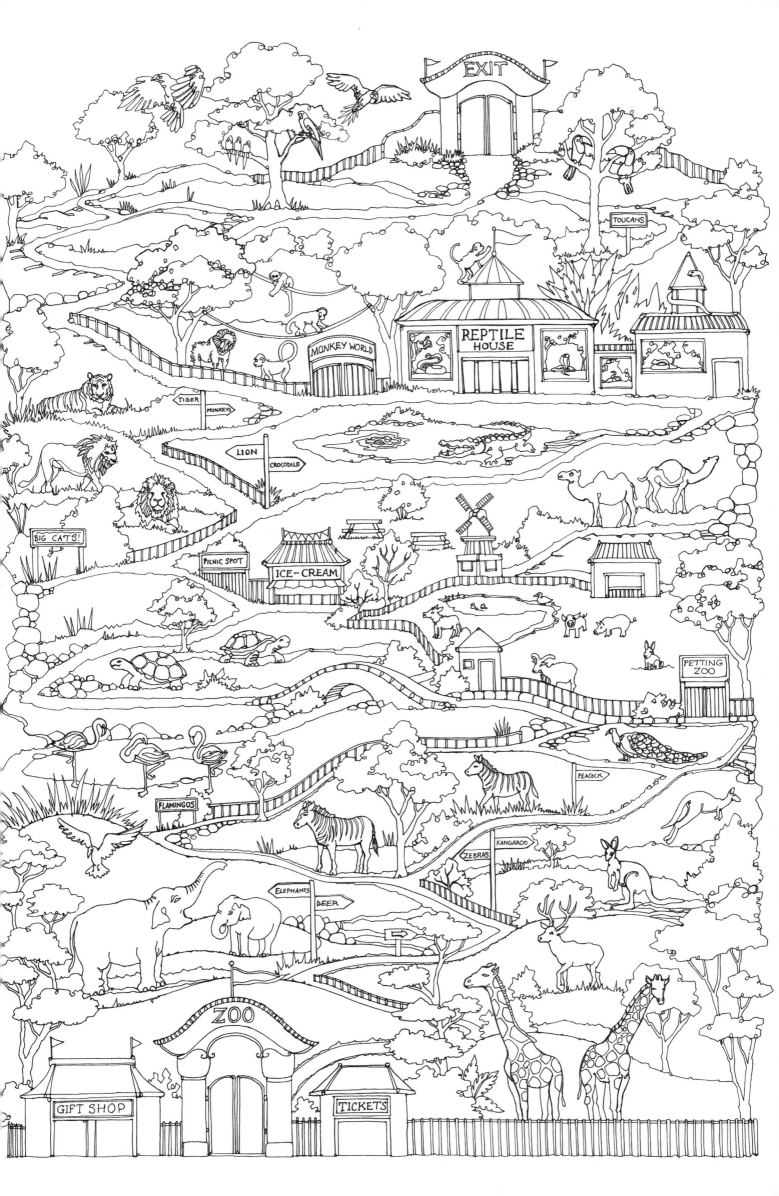

VERTICAL TRAIN STATION

Where do you want to go? The world is your oyster at the train station, where a waiting express train will carry you anywhere you would like to venture. Look up the destinations on the giant departures board overhead, and then buy your tickets from the bright and airy ticket office. Remember to check your platform number and departure time. Then take a moment to absorb the bustling atmosphere as you sip a cappuccino in the coffee shop, or maybe even enjoy a glass of wine in the VIP restaurant.

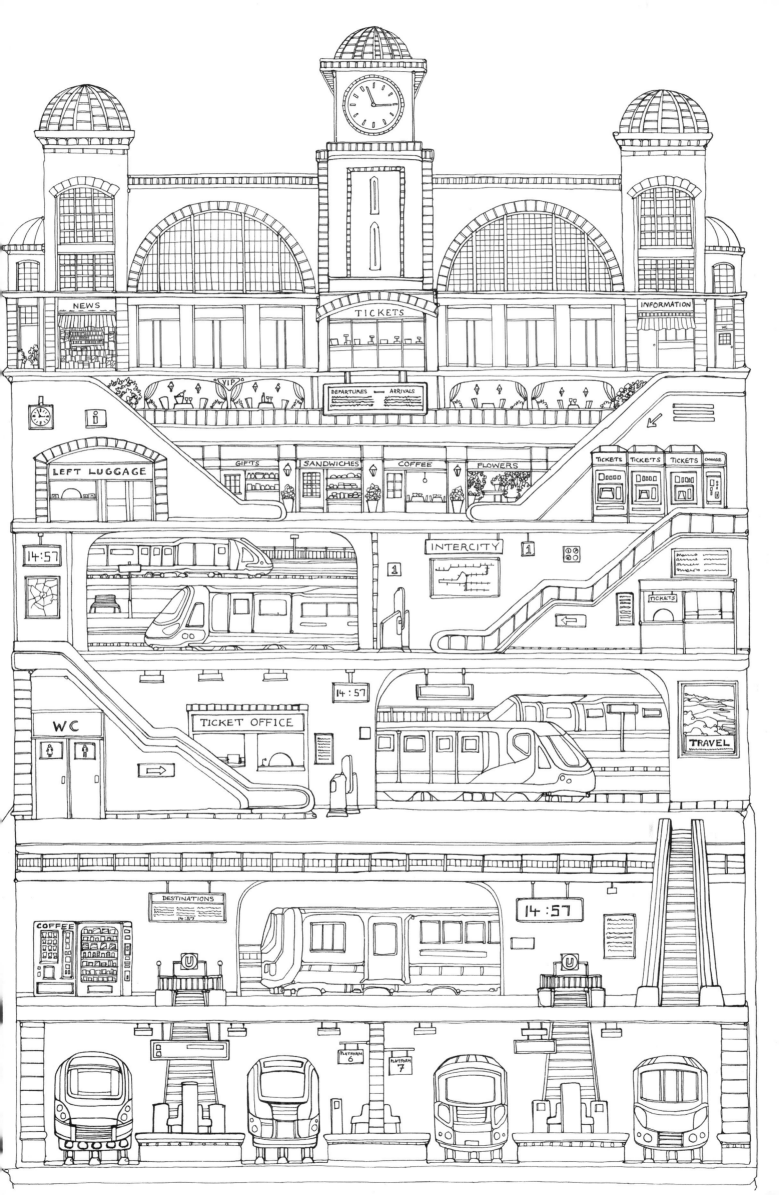

VERTICAL OCEAN LINER

Discover an entire village floating on the sea as you explore this luxurious ocean liner. Indulge yourself in the steam room of the Turkish Bath, take a dip in the pool, and admire the beautiful clothes in the fashion boutique. Practically everything you need is ready to set sail with you around the world, from a post office to send cards to loved ones, to a full-size cinema to catch the latest blockbuster. You'll be very busy, but don't forget to admire the view of the open seas!

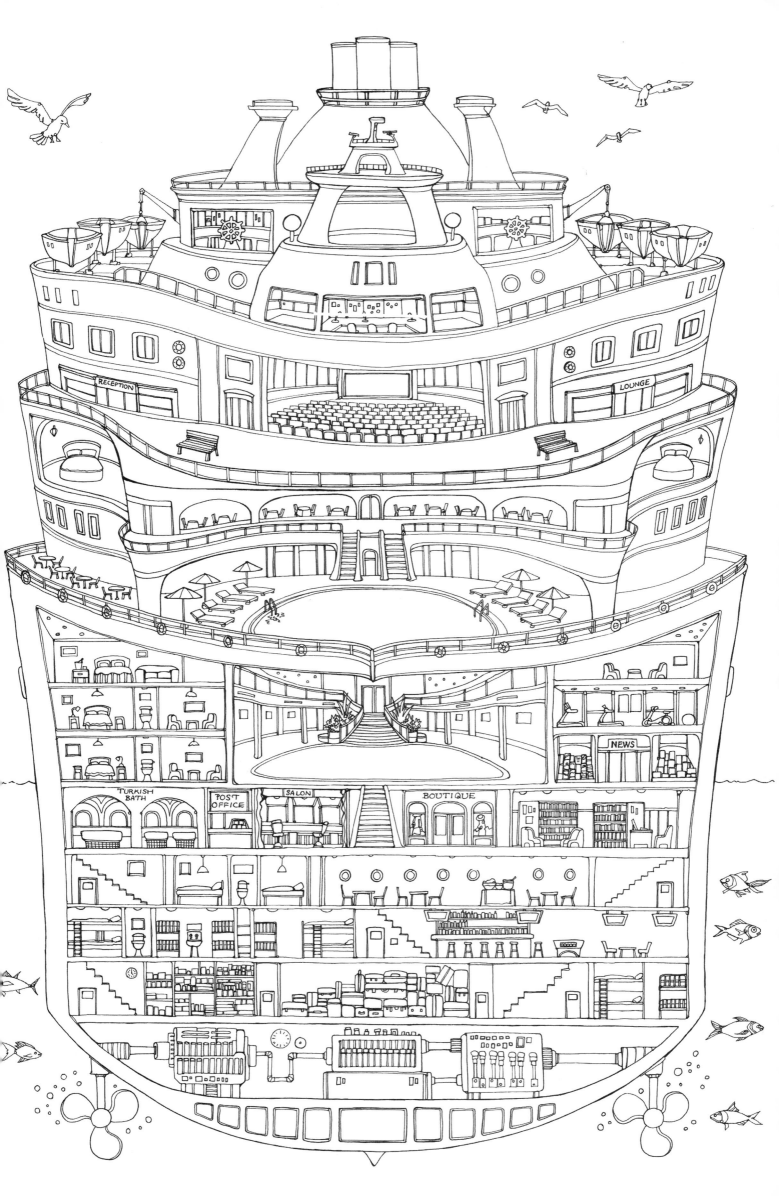

VERTICAL MANSION

Can you hear the bell ring as the grand lady of the house summons her maid to the drawing room? Upstairs, downstairs, there's never a wrong turn in this elegant and stately family home. After a morning spent browsing the antique tomes that line the library, climb the grand staircase and soothe your frayed nerves with an hour or two in the music room. Perhaps there's time for a stroll in the manicured grounds, or a nap in the fashionably appointed master bedroom, before the gong sounds and it's time to dress for dinner.

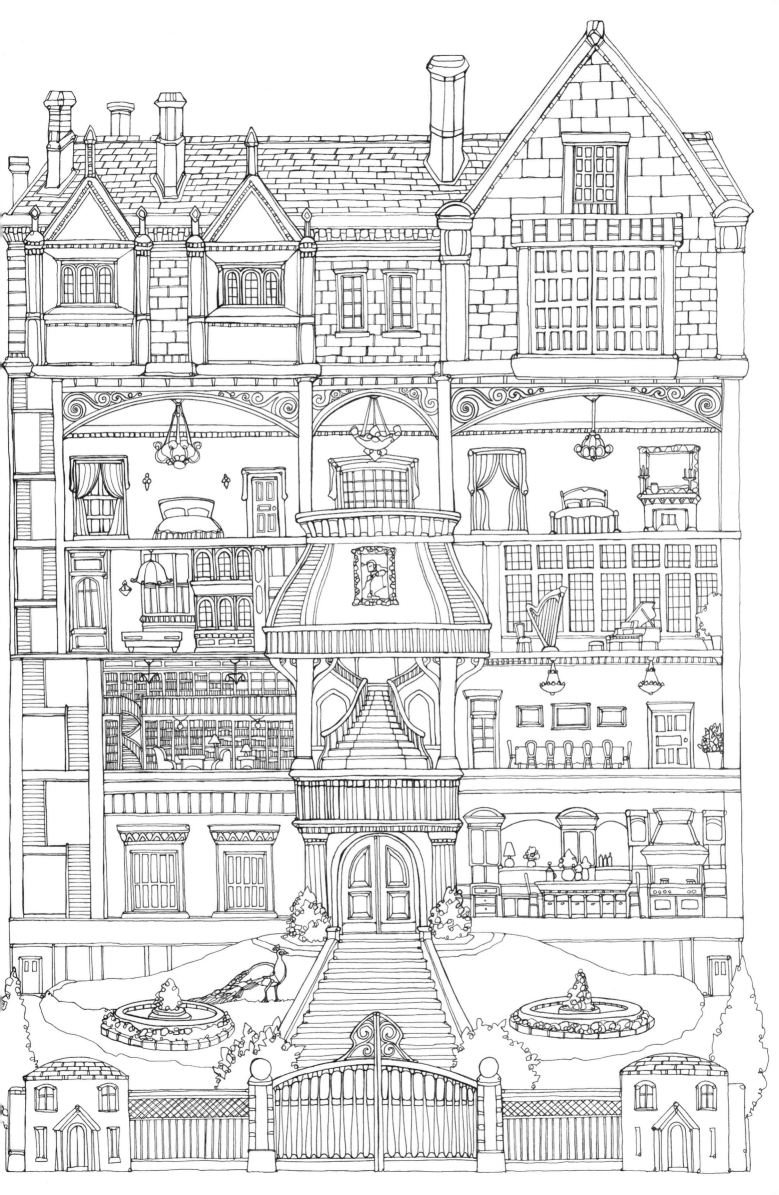

VERTICAL SUBMARINE

Deep beneath the ocean lurks this magnificent submarine. The powerful engines propel the vessel into mysterious, unchartered territory as it explores the depths of the sea, encountering all kinds of majestic marine life along the way. Navigate the underwater world in the map room, peer out of the portholes, and marvel at the complex engines powering the giant propeller. Or simply swing in a hammock in the living quarters, as you await the captain's order to "up periscope!"

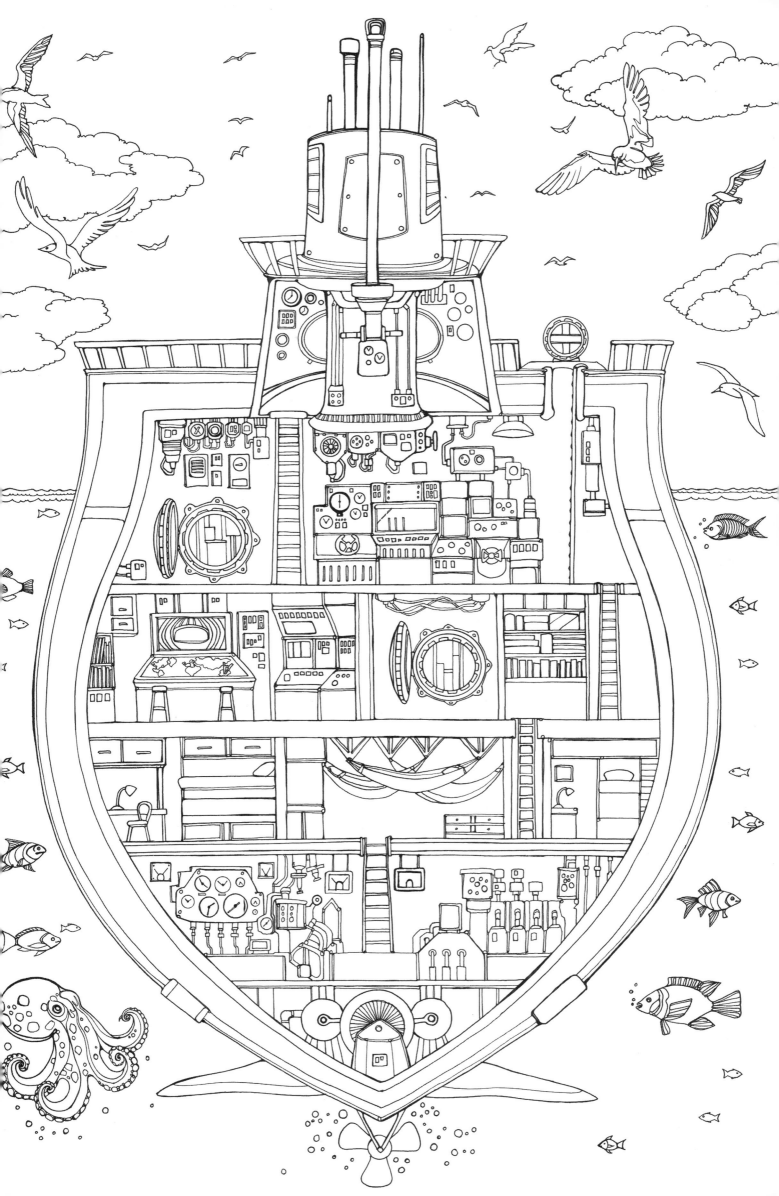

VERTICAL CATHEDRAL

Find a little moment of peace as you step through the door of the cathedral's intricate Gothic façade and enter into the echoing, vaulted space beyond. Light streams through the elaborate rose window, illuminating the gallery and pews below, while music pours down from the pipe organ and tumbling bells summon the congregation to prayer. Above, birds swoop through the flying buttresses and around the pinnacles, while towering spires point toward the heavens.

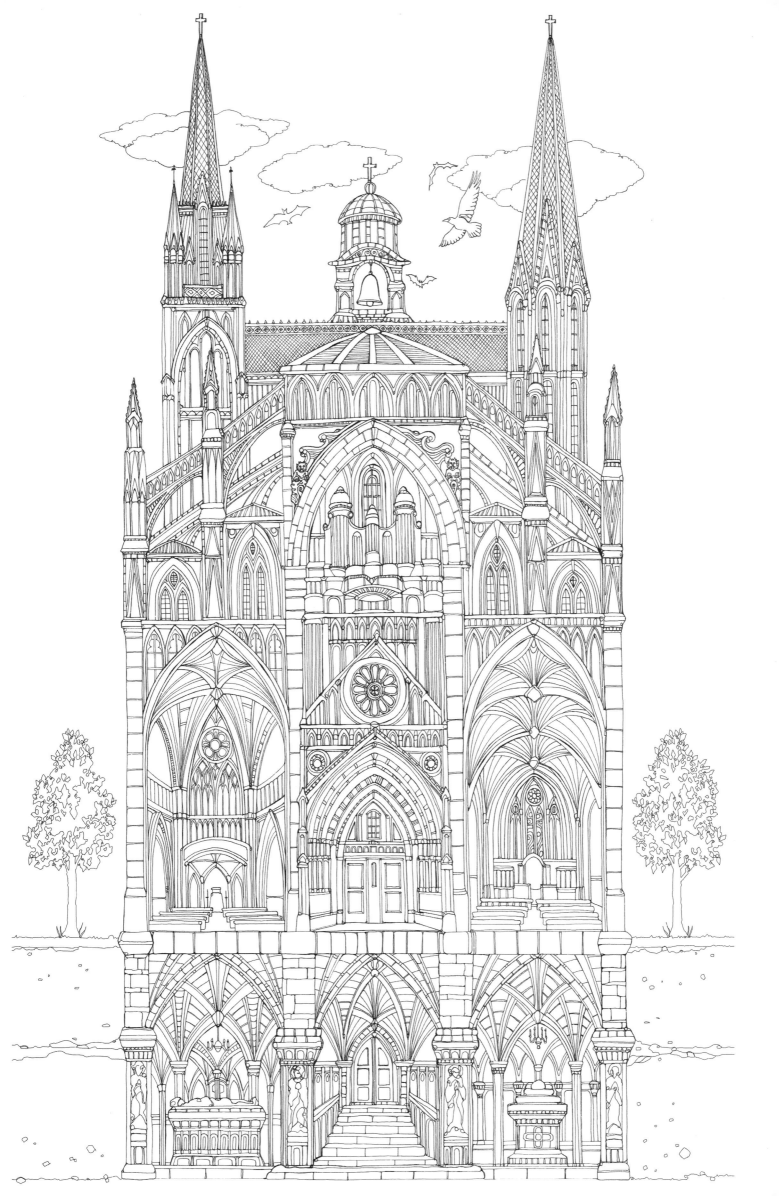

VERTICAL FARM

In the rolling green pastures of the countryside sits your very own rural paradise. As the chickens cluck outside the henhouse and the ducks swim on the pond, take a tour around and see how the crops and animals are thriving. Help the farmer plow the fields, milk the cows, and herd the sheep, before picking delicious produce from the orchard and vegetable patch. Then follow the winding path back to the cozy farmhouse and prepare a well-earned dinner.

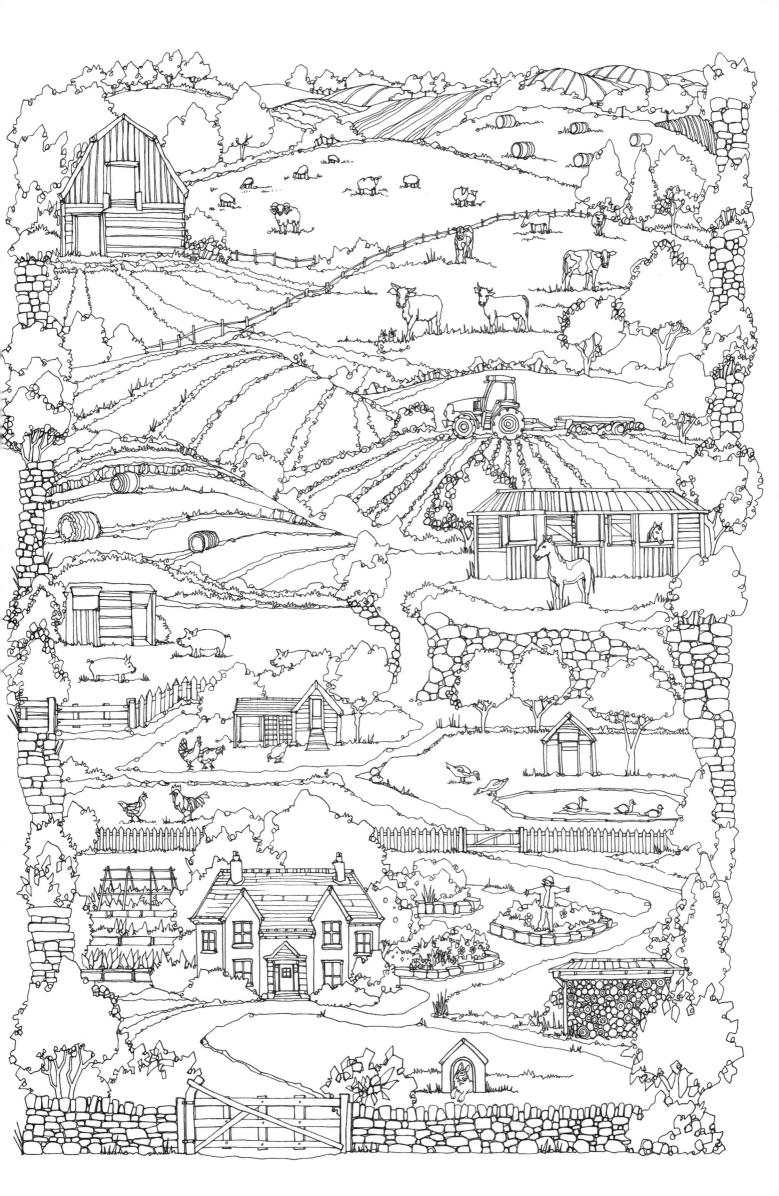

VERTICAL TREEHOUSE

Experience life among the treetops in this lofty wooden hamlet. Explore the different cabins nestled among the mighty branches, and use the web of rope bridges and ladders to climb higher and higher. Admire the panoramic view from your bird's-eye perspective, but do you dare to try out the perilous treetop swing? Later on, when the sunlight fades, lanterns cast a warming glow as you sit back to admire the starlit sky. You'll never want to come back down!

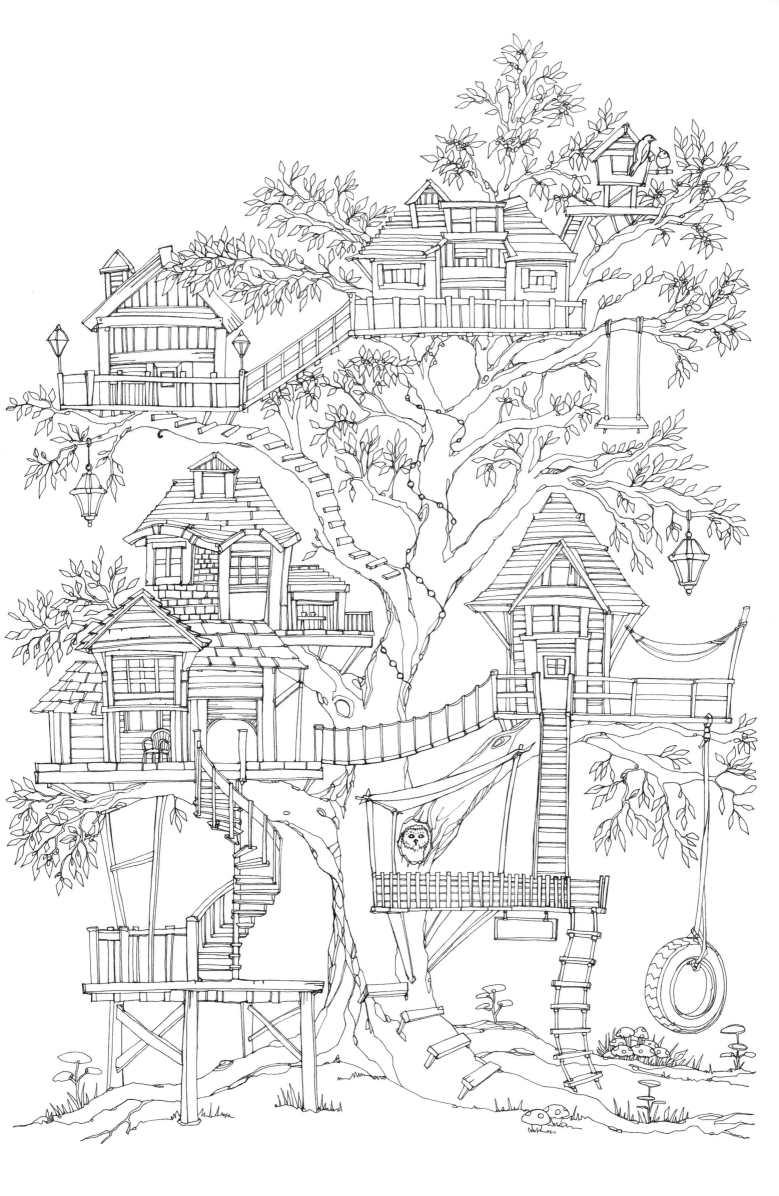

VERTICAL HOTEL

This grand hotel has everything you could possibly need for a truly decadent stay. Following a warm welcome from the concierge, sweep up the magnificent double staircase on your way to your sumptuously appointed suite. Once you've changed for dinner, have a drink in the bar and then sit under the chandeliers to enjoy the best meal you've ever had in the central dining room. After this, you'll sleep like a log in your comfortable king-size bed.

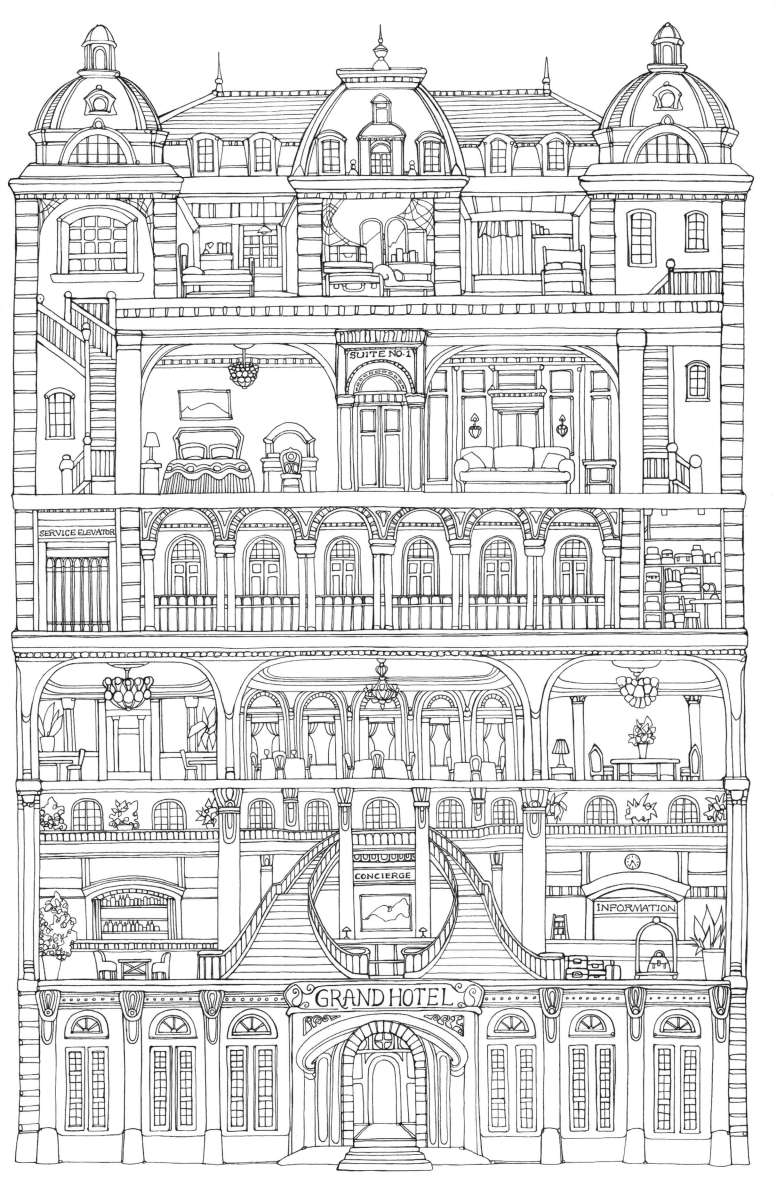

VERTICAL THEATRE

Come and catch a matinée or an evening performance in this beautiful space.
Whether you're mingling with the crowds in the stalls or perched in a glamorous
private box, the sounds of the orchestra pit, the heat of the spotlights, and the
bright colors of the painted scenery will fill you with anticipation as you wait for
the curtain to rise. During intermission, have a drink at the well-stocked bar or see
if you can spot any of the actors standing by their dressing rooms.

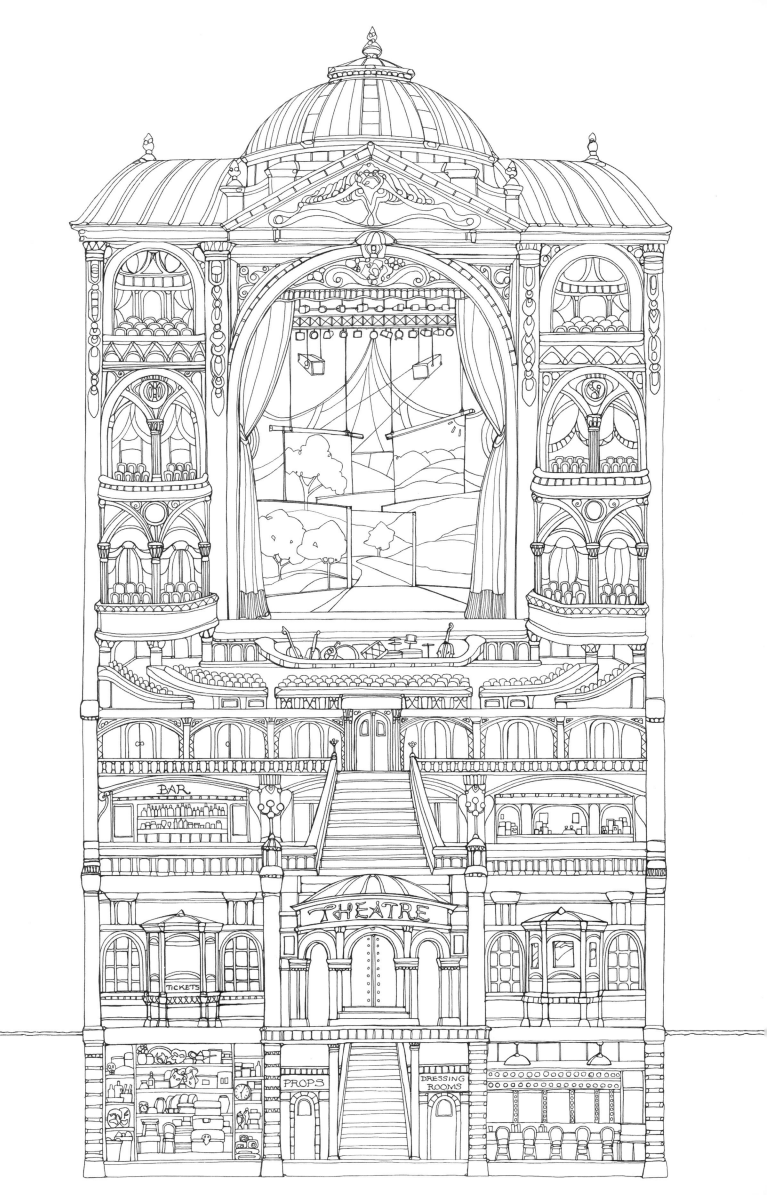

VERTICAL AIRPORT

Wherever in the world you're flying to, the airport will always be your first stop, so make the most of your visit while you're here. Print your boarding pass at the ticket counter and make your way to the gate. Stop along the way to grab a last-minute outfit from the clothes boutique, and stock up on some reading material from the bookshop. Once you've done your shopping, have a drink and something to eat from one of the restaurants or cafés, toasting a "bon voyage" as you go.

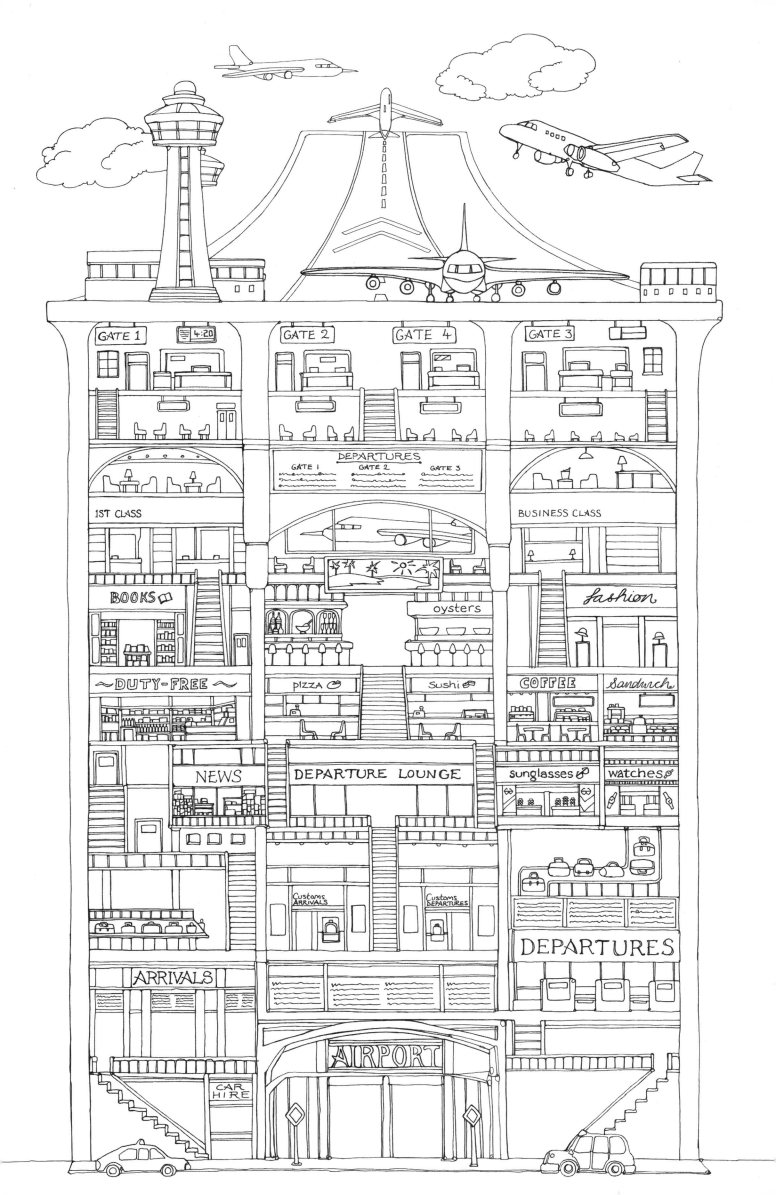

VERTICAL FACTORY

Come and see the assembly line in action as you tour the car factory. From the very first sketches on the drawing board to the shiny vehicles sitting in the showroom, every aspect of the manufacturing process is on display. On the factory floor you can try your hand at assembling parts with the help of the robotic technicians, then watch the cars roll off the production line and into the sparkling showroom. Will you be tempted to hit the road in a brand new car?

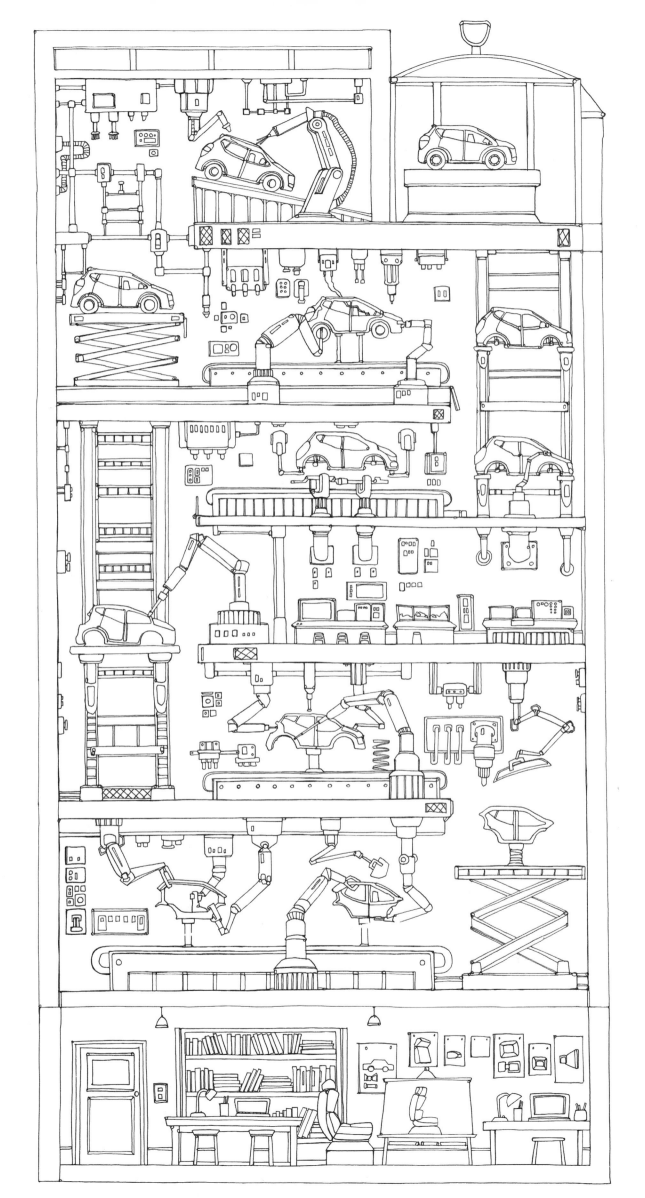

VERTICAL GYMNASIUM

Raise your heart rate and flex those muscles with a thorough workout in the gymnasium. Whether you prefer the climbing wall or lifting weights, you can be sure that the gymnasium is the perfect place to exercise. Play team games in the hall or take a turn on the treadmill to help keep up your fitness levels; whichever you choose, you'll find all the equipment you want in this state-of-the-art facility.

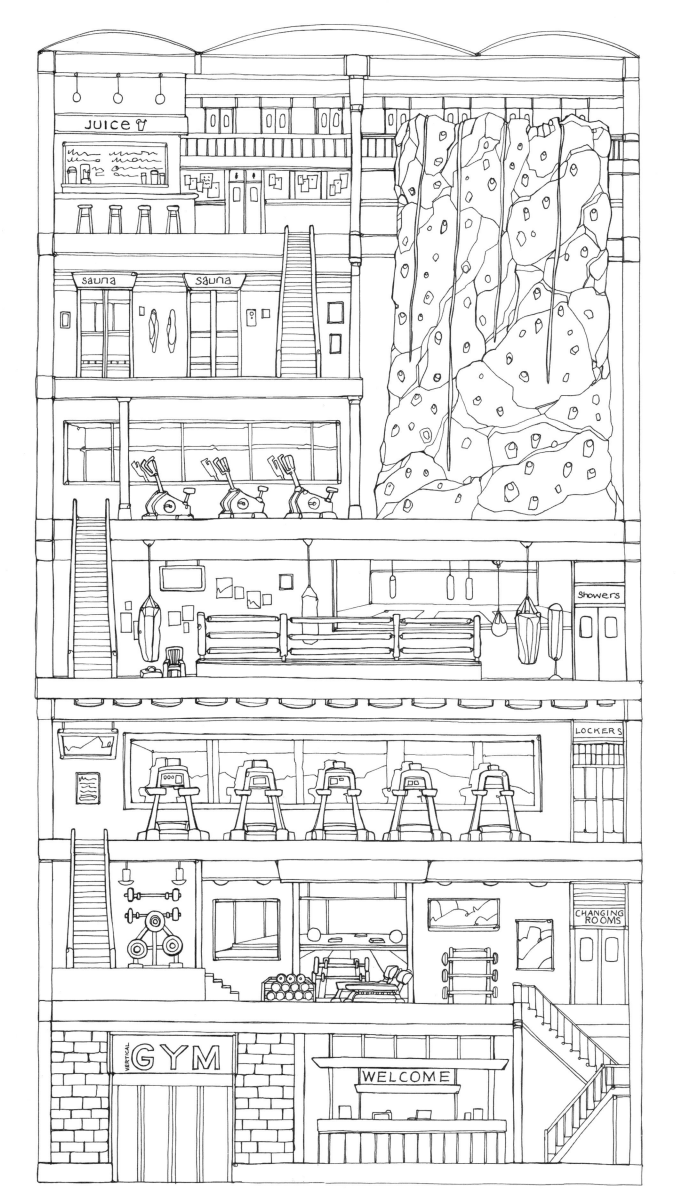

VERTICAL SUPERMARKET

Push your shopping cart through the aisles of the supermarket and choose from the cornucopia of goods laid out in front of you. Pick up all the ingredients you need to cook a delicious dinner, alongside all kinds of essential household goods. The supermarket really does have everything you want under one roof, making the weekly trip to the store a pleasure rather than a chore. Cross off your list as you go, selecting everything from steaks to strawberries, cucumbers to cakes, and anything in between!

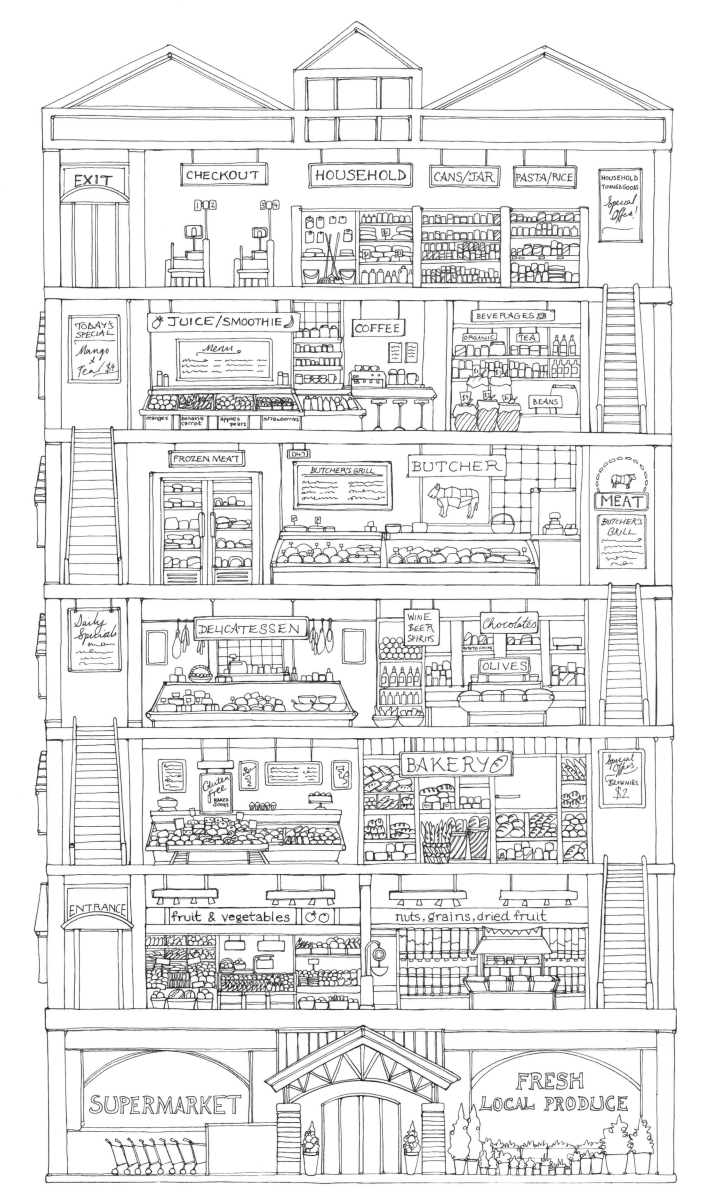

VERTICAL ART MUSEUM

Soak up some culture as you wander through the art museum. Here there are works of art from every place and period imaginable, from Roman sculptures and French Impressionists to Chinese calligraphy and African pottery. Attempt to sketch your favorite picture, or buy a postcard from the gift shop if you're less sure of your artistic skills! At the end of your visit you can stop for a snack in the café, sit back, and reflect on what you have seen.

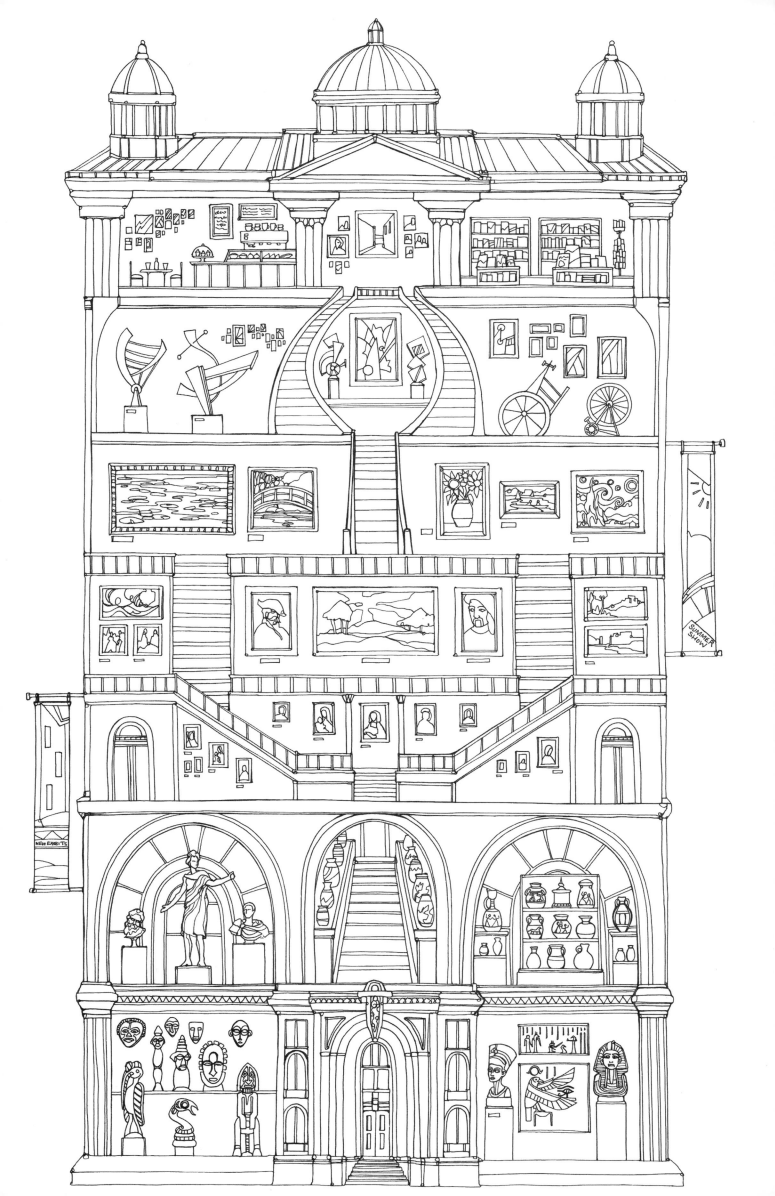

VERTICAL BAZAAR

This bustling marketplace gives you a real taste of the exotic. Absorb the lively atmosphere as you browse the stalls, breathing in the heady scents of perfumes and spices. The crafts on display reveal the intricate handiwork needed to make them, while the food stalls tempt you to try something a little different. Practice your haggling skills and see if you can pick up a bargain!

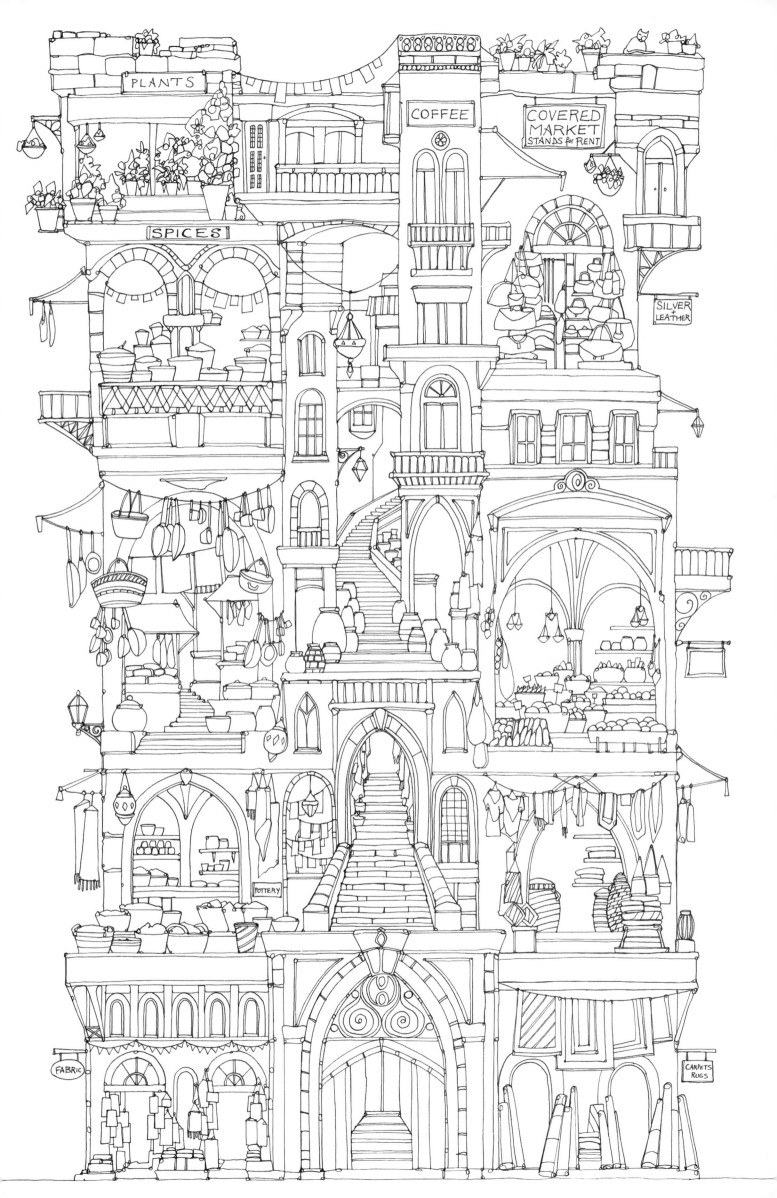

VERTICAL SPACE STATION

Experience zero gravity as you float through the space station. The planets and stars visible through the window as you orbit Earth will make you truly appreciate the beauty of the universe. In the station, help the astronauts to navigate the route through the cosmos, then take your turn preparing some vacuum-packed space food for the hungry crew. Remember to practice your moonwalk!

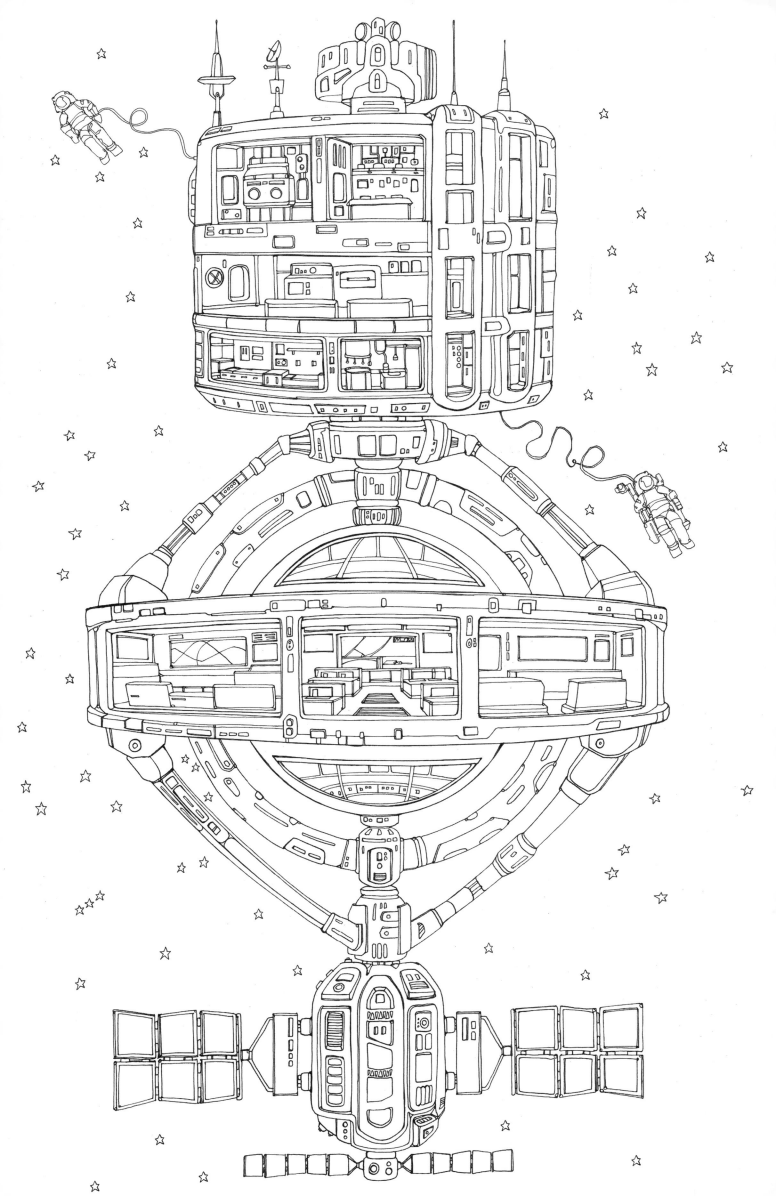

VERTICAL MUSIC FESTIVAL

Under summer skies, the music festival is a wonderful place to enjoy all of your favorite things—music, food, and sunshine! Pitch your tent on the campsite, then head over to the stage and see if you can spot any famous faces mingling with the crowd. The flags and banners will direct you to wherever you want to be, whether it's at the edge of the stage singing along to every word or grabbing a delicious bite to eat from one of the pop-up food stands.

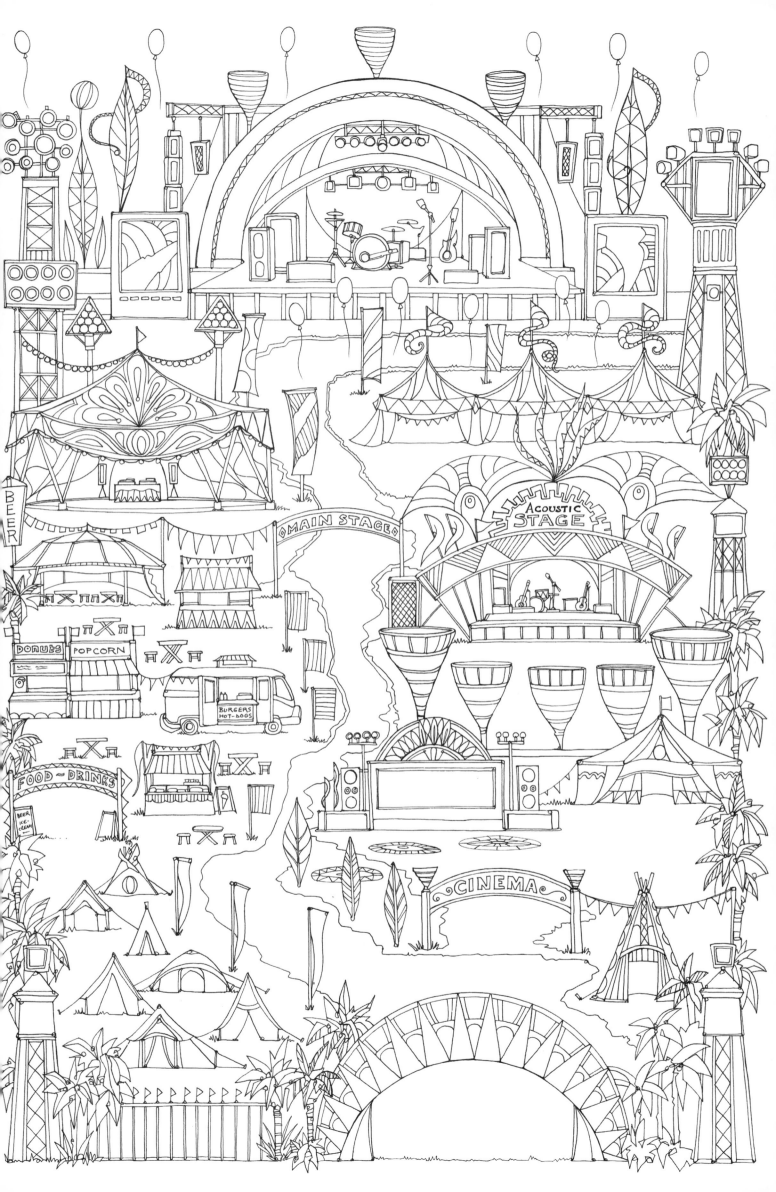

VERTICAL DEPARTMENT STORE

It's easy to see why shoppers choose to spend all day browsing the floors of the department store. Luxury goods of every kind stretch from floor to ceiling, encompassing everything from elegant suits to elaborate mirrors. The department store has something for everyone; the toys on the top floor will delight children of all ages, while the kitchenware will please even the most exacting cook. Whether you've just popped in to browse or are looking for something in particular, you'll be sure to leave with something new.

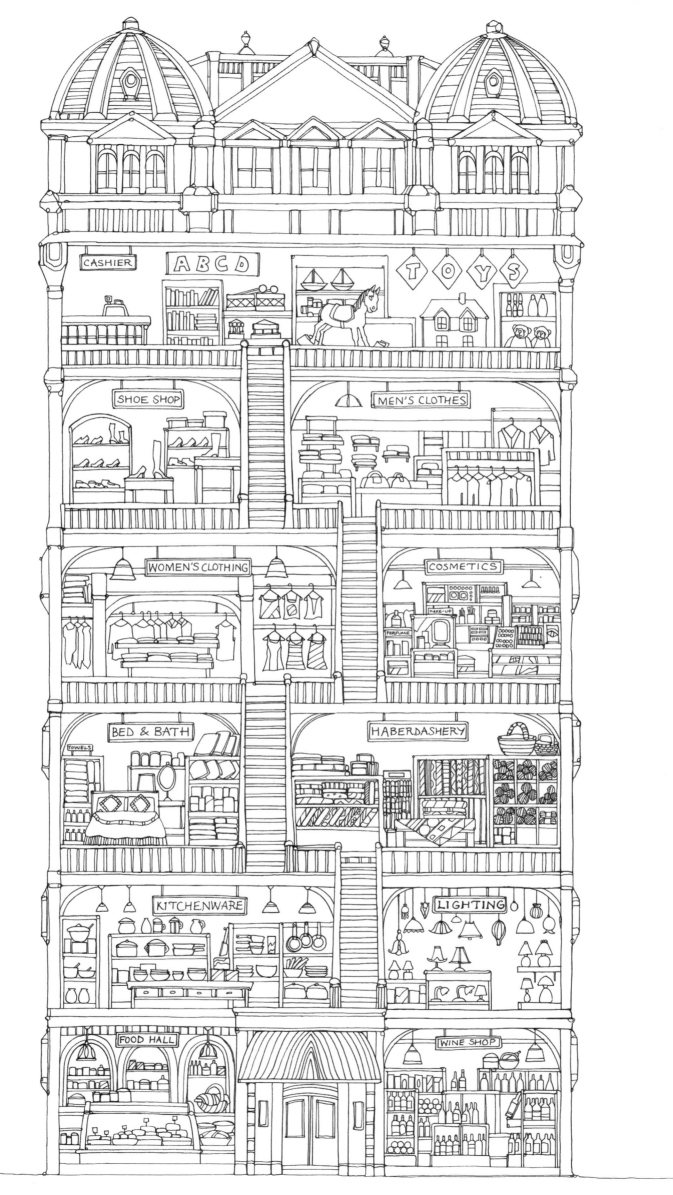

VERTICAL OFFICE

Chair a meeting, draw up some spreadsheets, and spin around on your swivel chair as you spend your day in a bustling office complex. Send your emails and type up notes at your desk, then catch up with your colleagues at the watercooler and go for lunch in the staff cafeteria. In the afternoon, give a presentation to your team and update your boss on the progress of your latest project before clocking out and heading home.

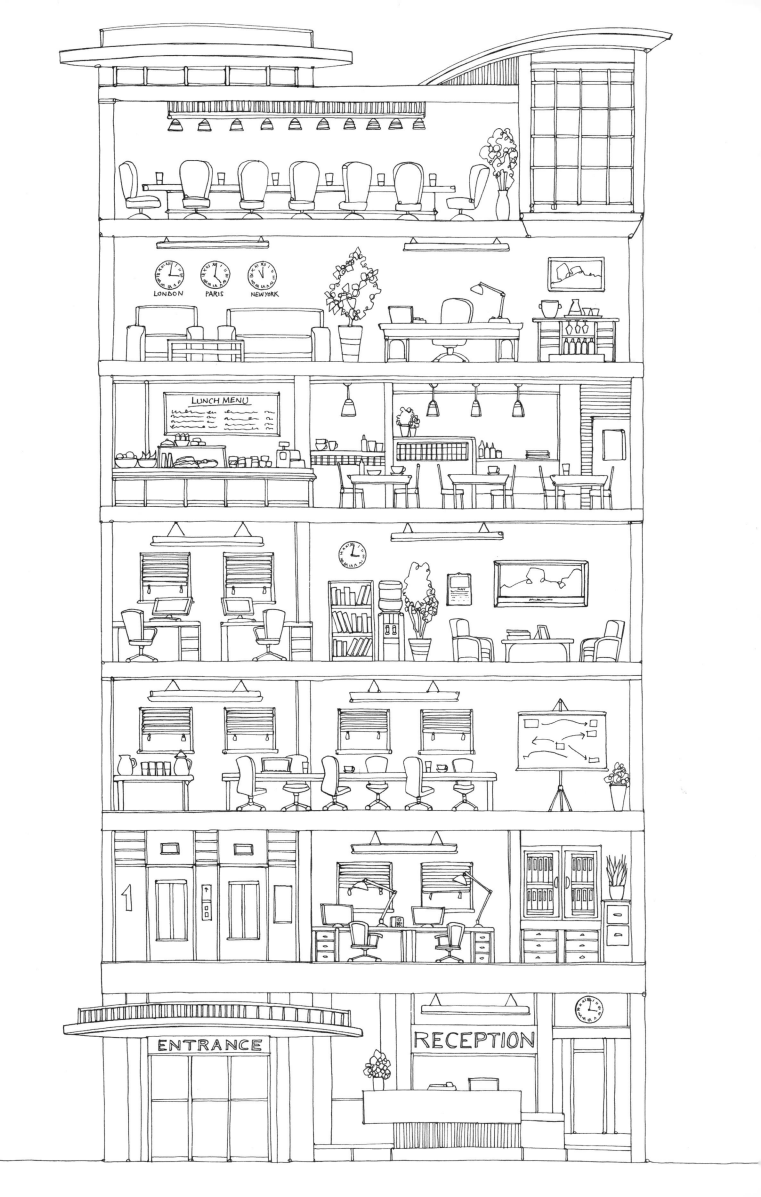

VERTICAL FILM STUDIO

It's "lights, camera, action!" at the film studio. Beautifully made sets showing scenes from some of your favorite films line the walls, while the storage closet is a treasure trove of props and costumes waiting to be explored. Look around the studio and see how to frame the perfect shot, as the cameras are moved and the lights are positioned at the best possible angle. Wait for your cue, then hit your mark. Are you ready for your close up?

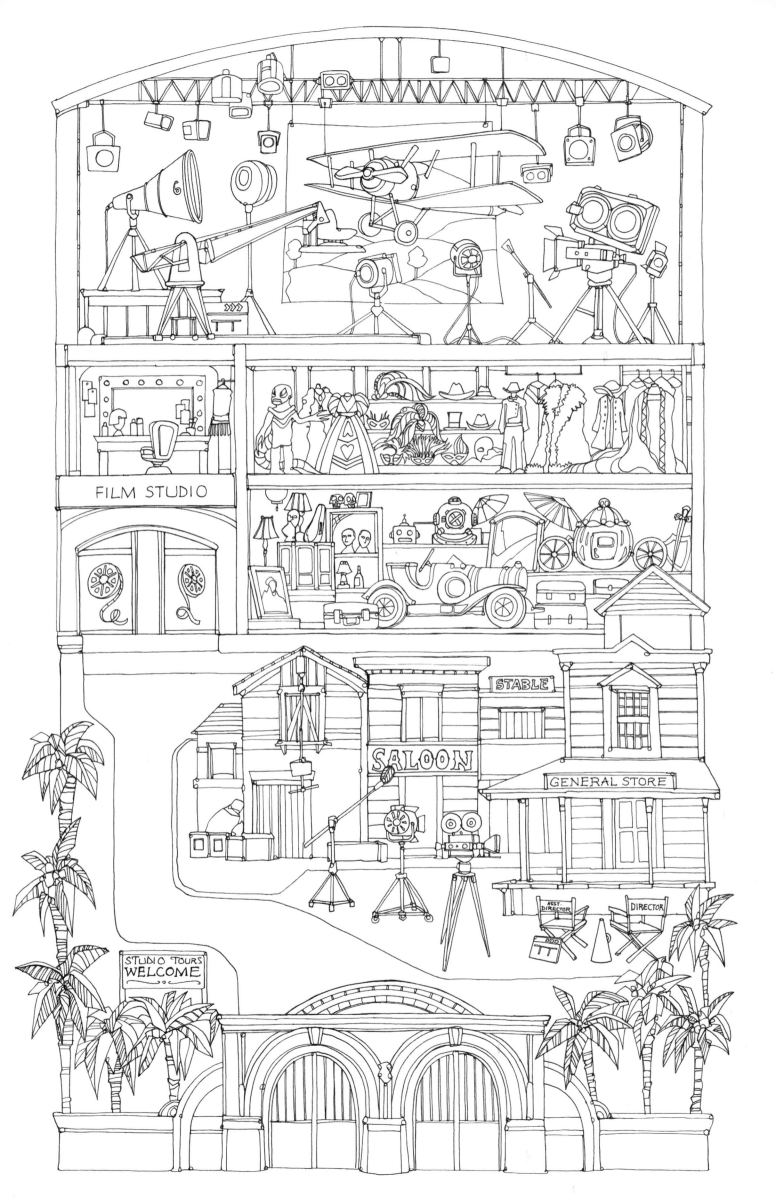

VERTICAL AQUARIUM

Discover an underwater kingdom as you wander among the tanks of the aquarium. Brightly colored tropical fish dart all around you, crabs scuttle along the floor, and seahorses weave in and out of the weeds, recreating life at the bottom of the ocean. If you're feeling brave, go and visit the sharks at feeding time and marvel at their ferocious teeth. If you would prefer something a little more tranquil, watch the turtles swim gently around their tank instead.

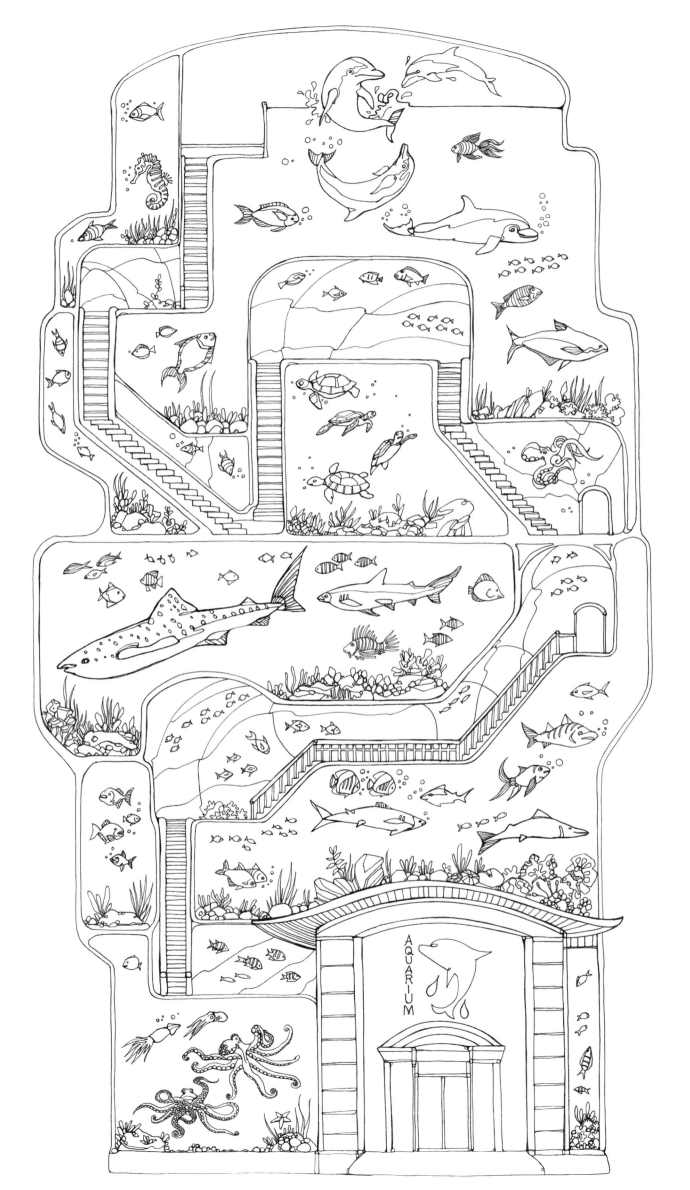

VERTICAL NATURAL HISTORY MUSEUM

At the natural history museum, exhibits of plants and animals from millions of years ago reveal the wonders of the natural world. Pick your favorite specimen from the ancient fossils that sit alongside huge mammoth tusks and dazzling minerals, showcasing the collections made by the first naturalists centuries ago. Here you can trace the evolution of life on Earth from dinosaurs to modern-day humans, viewing incredible examples of just about every species in between.

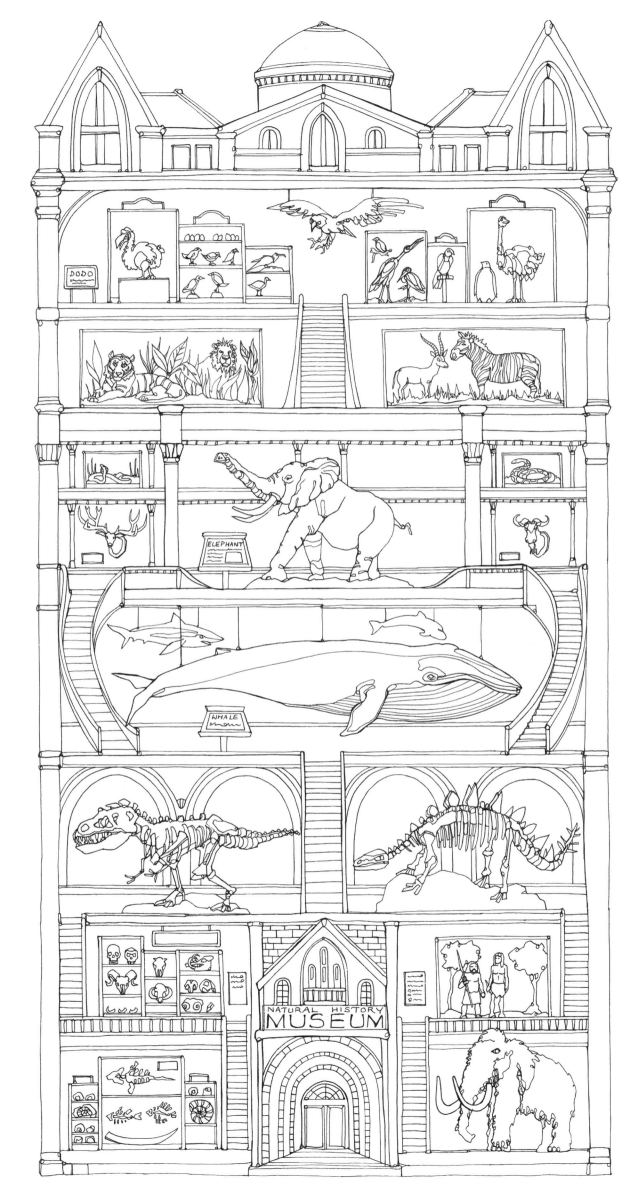

VERTICAL UNIVERSITY

Become a student for the day and experience what life on campus has to offer. Attend a lecture on your favorite subject, then head to the library to pick up the books you need to make a start on your essay. Once you've done a bit of work, it's time for a break—grab some lunch in the dining hall and catch up with your friends. After you've been to your afternoon classes, meet up with your roommate at the dorm and make plans for the evening's fun.

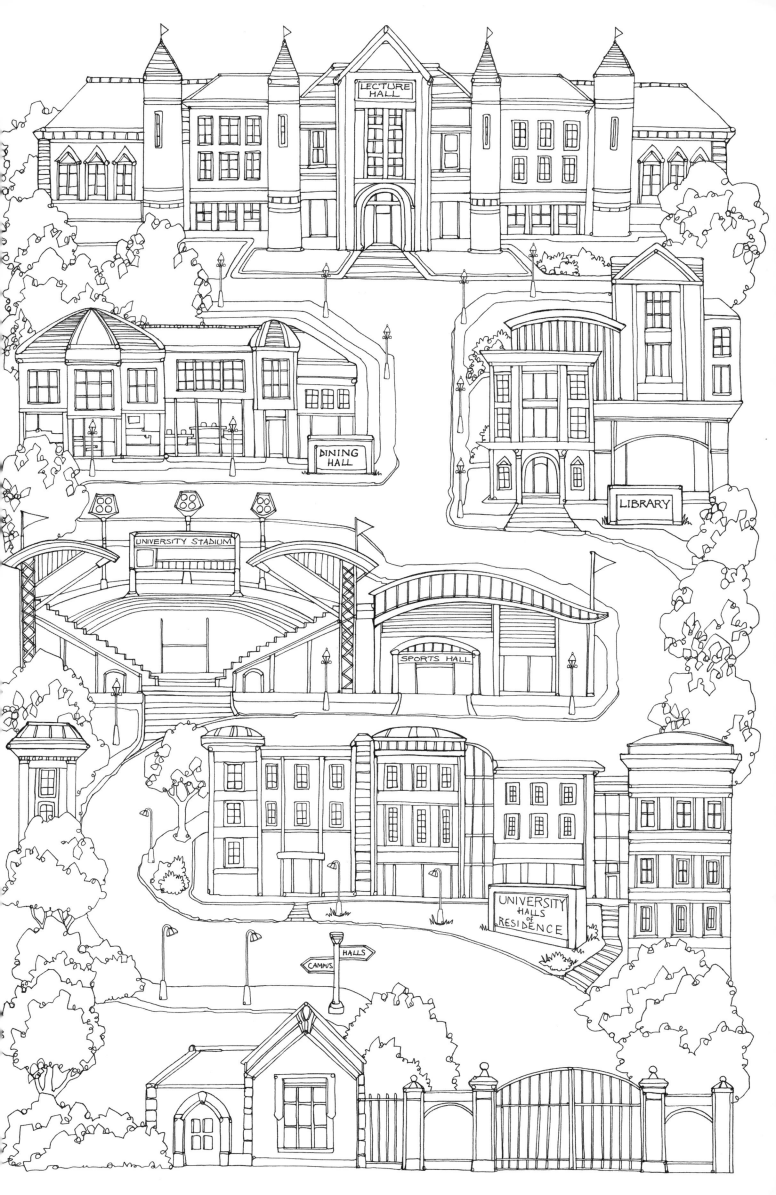

VERTICAL CARNIVAL

Come one, come all, for fun, food, rides, and slides! Balmy summer nights were made for carnivals. Brave the ghost train, zoom down the helter-skelter slide, lock horns on the bumper cars, and whip around the roller coaster. Or why not win your sweetheart a prize at the shooting gallery before cozying up on the Ferris wheel. End the day with your favorite carnival snack and a ride on the carousel.

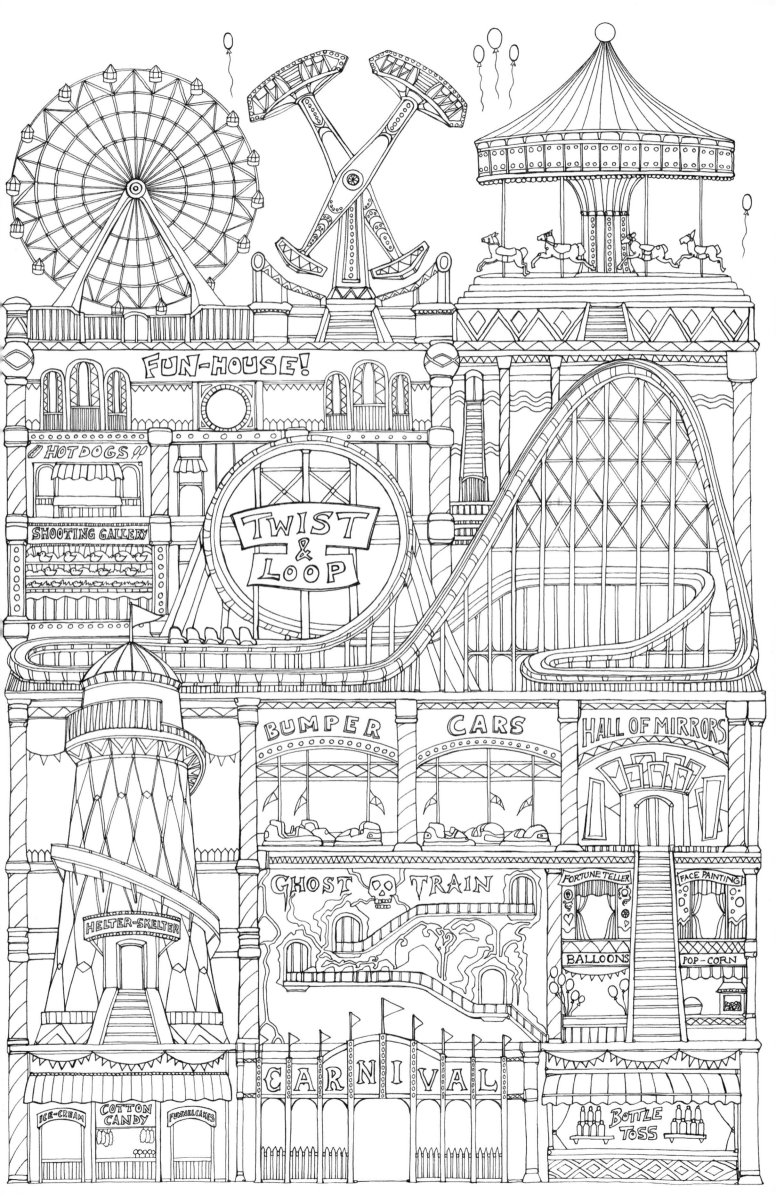

VERTICAL VISUAL INDEX

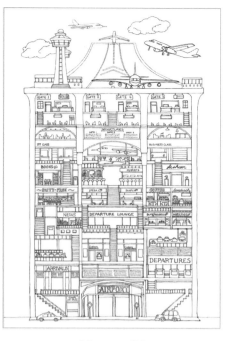

Airport 30

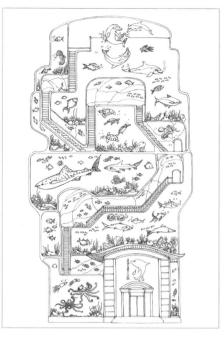

Aquarium 52

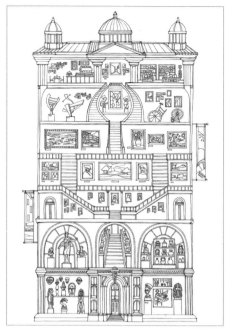

Art Museum 38

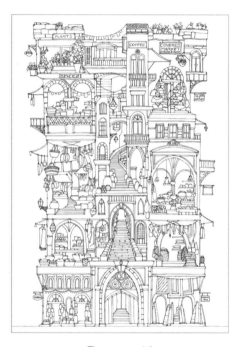

Bazaar 40

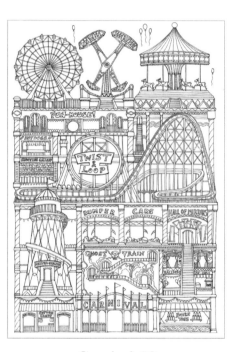

Carnival 58

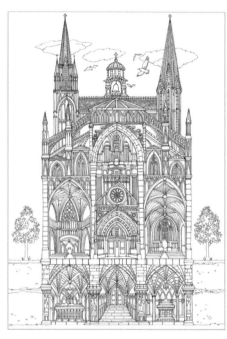

Cathedral 20

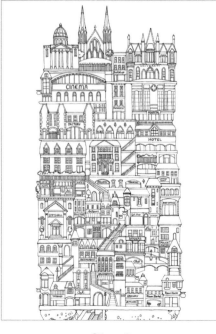

City 6

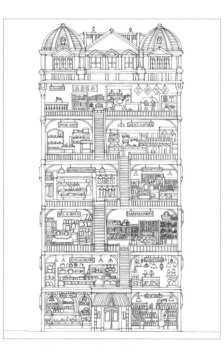

Department Store 46

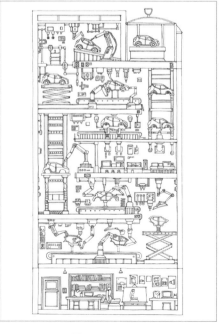

Factory 32

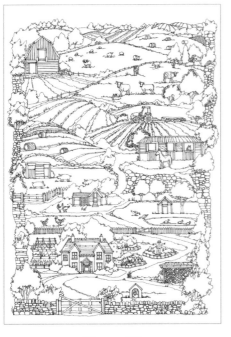

Farm 22

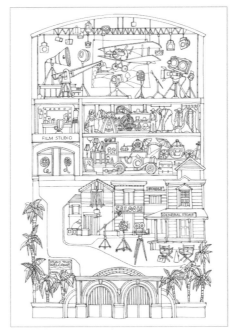

Film Studio 50

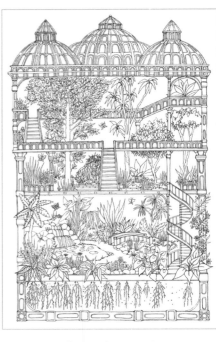

Greenhouse 8

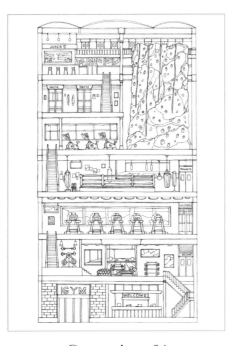

Gymnasium 34

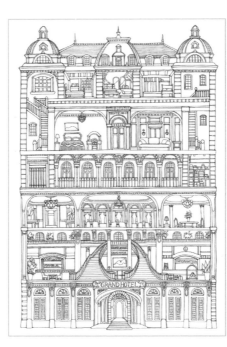

Hotel 26

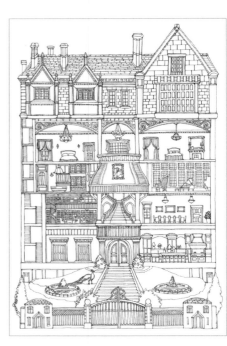

Mansion 16

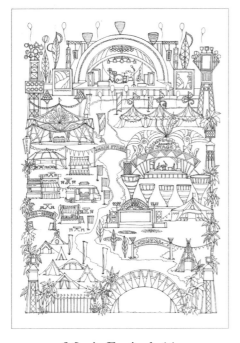

Music Festival 44

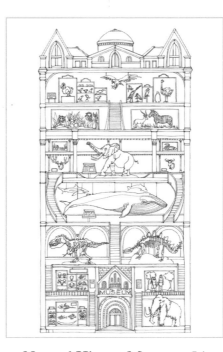

Natural History Museum 54

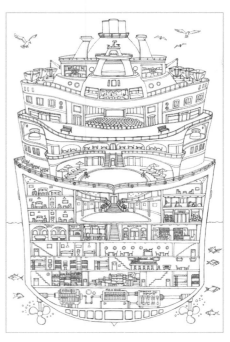

Ocean Liner 14

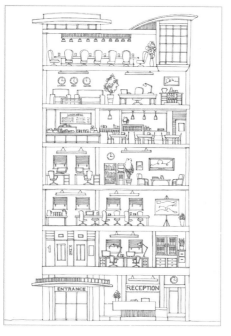

Office 48

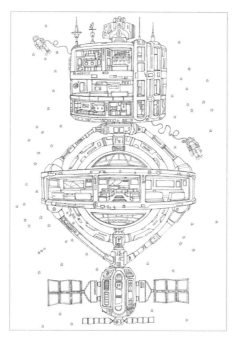

Space Station 42

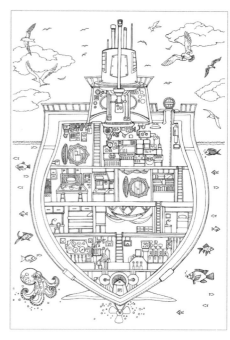

Submarine 18

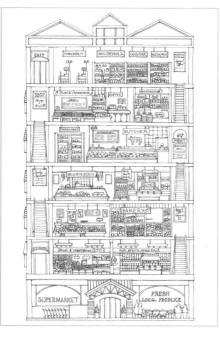

Supermarket 36

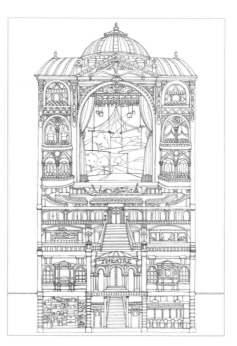

Theatre 28

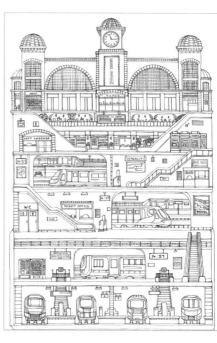

Train Station 12

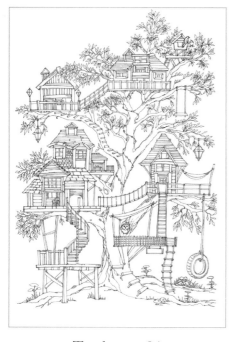

Treehouse 24

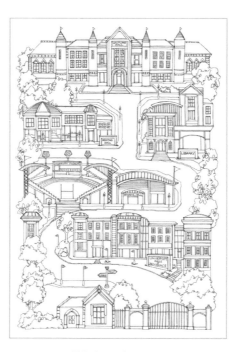

University 56

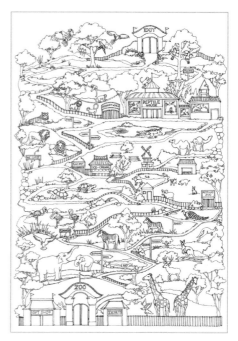

Zoo 10

Conceived and produced by
Elwin Street Productions Limited
14 Clerkenwell Green
London, EC1R 0DP
United Kingdom
www.elwinstreet.com

ISBN: 978-1-4197-2270-7

Printed and bound in China
10 9 8 7 6 5 4 3 2 1

Abrams Noterie products are available at special discounts
when purchased in quantity for premiums and promotions
as well as fundraising or educational use. Special editions
can also be created to specification. For details, contact
specialsales@abramsbooks.com or the address below.

ABRAMS The Art of Books
115 West 18th Street, New York, NY 10011
abramsbooks.com